T0161886

I have spent a lot of time in my life thinking about Eddie Hazel, about what it is to be known for one bright burst of time, and then little else. Adrian Matejka was one of the first poets I read, one of the first poets I loved to read. For all of the reasons that are on display here: an ability to honor the stillness of a moment— to zoom in and pick apart all of its movements. To attach the self to the past as a way of illuminating it, and then backing off when needed. I first adored the work of Adrian Matejka because it was the work of a bandleader. Patient, clever, controlled, visionary. It is refreshing, to return to his work once again, and be as in awe as I always have been.

– Hanif Abdurraqib

STANDING ON THE VERGE

Words
Adrian Matejka

Art
Kevin Neireiter

Music
Funkadelic

FOR MORE INFORMATION
Password: Funkadelic

For more information:
Third Man Books, LLC, 623 7th Ave S, Nashville, Tennessee 37203.

ISBN 9781734842296

Layout by Maddy Underwood

THIRD MAN BOOKS

Contents

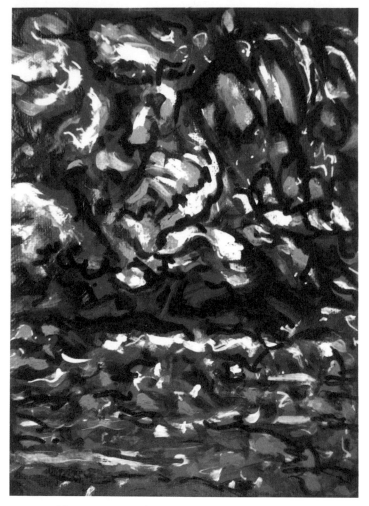

Adrian Matejka

"close to you as rough-printed fingers get to guitar strings."

Red Hot Mama

...you sure look good to me...

I see you, stamping around the luscious
corner in leopard print boots & thigh
wonder. Me, full of intent at the sight
of those metronoming hips. I'm trying
to see those dimples & not flip. I'm trying
to be in these slipshod acoustics without
tripping. Hooked & wanting to stay shook,
close to you as rough-printed fingers get
to guitar strings. Their avuncular vernaculars
fretting just like us. Yeah. Bighearted
striations strutting just like us. Yeah.
Mouths full of smoke, gloriously red
& upturned in the late-night singalong.
All these glittering highlights: skin
is the upside of lips, so just go on, mama.
You got me symmetrically split. You got
me cresting & leather slick: a whole
silhouette of wax & citrus & whatever
comes out will be objectively lit.

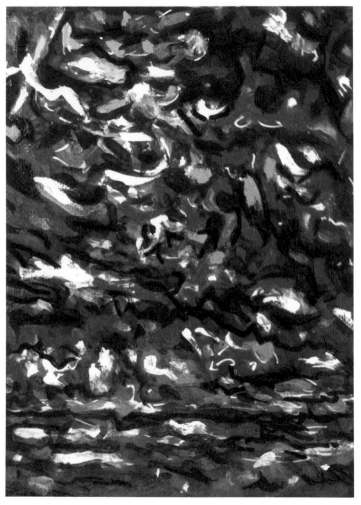

"Bighearted striations strutting just like us. Yeah."

Adrian Matejka

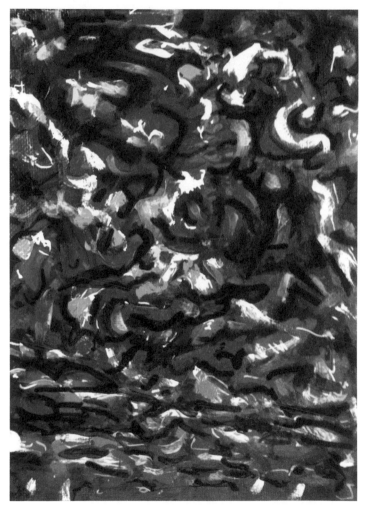

"red toes conundrummed into whip smart dirty talk"

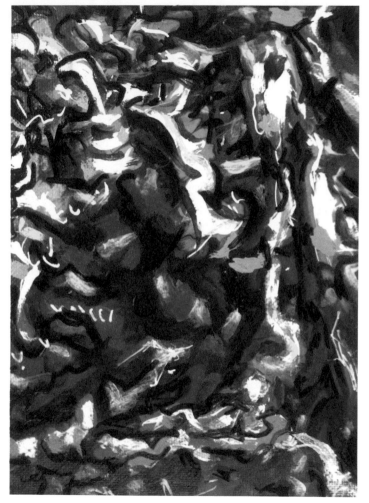

"We're we"

Adrian Matejka

6

Alice In My Fantasies

...They call it mental masturbation...

& that's when the guitar parades shred in my head & the flags over
 the winking skyscrapers raise their finger Vs downtown in the sun
& the dented brass bands & exhausted embouchures & the patriotic

local singers—tonsils like exclamations, tongues on the points—
 sing like Bootsie: *Alice in my fantasies promised to do all kinds*
of things to me. Your name doesn't rhyme with Alice, but the fantasy:

real fingerprints on your feedback neck, red toes conundrummed into
 whip smart dirty talk at the back of the fishnet gallery. So many
intentions, especially with your heels off & dangling loose at your side,

fingers hooking their bright straps. The next thing you know, the whole
 parade is turned up behind cigarette dragons & funky emotions &
we're in somebody's bathroom trying to unzip with hands like mittens.

What astonishment, what a hotbox of intent & the record wobbles under
 Bootsie's bass. We're nobody's fantasy now. We're *we* & we
don't even know anyone named Alice. You're not trying to get up off

of the shoddy hotel couch as a country of intentionality divides
 fantasy from stockings—shirts & skirt scattered like all
the other make-believe before these, spotlights like somebody's tautology.

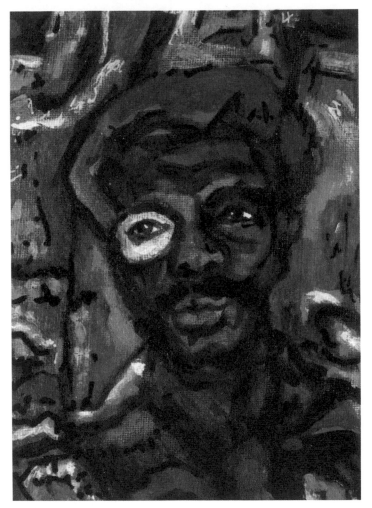

"Funk is always on the one"

8

I'll Stay

...for she'll be coming back...

for all of it. The want & tumble.
The word fumbles in the late-
night halogen. She's gone again
& in the leftovers, my hands meet
the busted slice of life before
the big spread. What I want is
a better word for *all of it* instead
of the triple X on my liquor jug.
What I want is a sheepskin shrug
for my late-night addendums
& erections, those hip shakes
on the dialectical dance floors
each & every spring. Here we go
with that seasonal bullshit again.
Excuse my French. Put on your
earphones so your eardrums don't
get beat out by the sense of it.
Push up your star glasses, too,
instead of fucking it. Funk is
always on the one, full of thumping
tongues & low-down uncertainty.
So now I'm asking for some

harmony to backdrop this insistent
curfew. Now I'm asking to be
chorusing in the morning grass,
the woman I always wanted:
next to me & covered in dew.

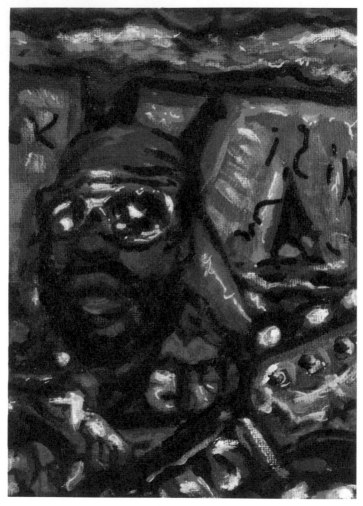

"a sheepskin shrug"

Adrian Matejka

"my late-night addendums"

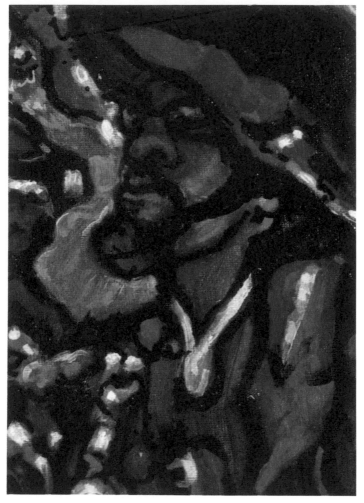

"My tasteable & unflappable wants"

Sexy Ways

...I love all of you & you sure enough got a lot...

There you are, all up in the luminosity of my hamstrung
& lucky morning. Somebody's about to get bent out here.
Probably me. From Indy to that bit-clean ocean where
blues contiguously move upside down. From the churlish
White River back to the brown curls of Detroit humidity:
I've been waiting to be this way my whole solo career.
In a rented house, the light just right on galaxies of ribs
& wrists. In the hypnotic house awash in brass bodies
like an ocean of coins & notes. Like the time I lost
my undropped acid on the carpet, I'm on my knees again,
searching the ceiling for familiar prophets, reoccurring
secrets. No choice but to slap you on your tambourine
& hope we both like it. My tasteable & unflappable wants:
as stretched as the stocking you blindfolded me with while
the song clinks what it wants with generous little cymbals.

Standing On The Verge Of Getting It On

...People, what you doing?...

It starts with big frisks in half-disc days.
Cavalcade of wants, slim décolletages
all up in the affluence of forgetfulness.
The haberdasher forgot a necessary button
& now the ready body talks through the space
between zippers. This land of shiny unbuckles
& high heels. Geography of *I like it* so much.
Topography of *I want it* so much as we walk
up the backside of a treble clef. It's an actual
epistle—seaside with the heavy clouds,
slick sunbathers minding their own libidos.
Hair ties high noting wrists in the long arch
& excavated bites in the land of rough play—
red & smitten by the bright lake, a city
of fights right behind us. These sticky trees
burning beautifully, these edged *pee on me's*
at the ledge of decency. Sometimes the tongue
trips & it feels like a slip down the throat
of a handy trumpet. I still don't know how
it ends: leathery reliquary in my thin falsetto
maybe, while your hips look like a couple
of question marks just about to hook up.

Adrian Matejka

"*the affluence of forgetfulness*"

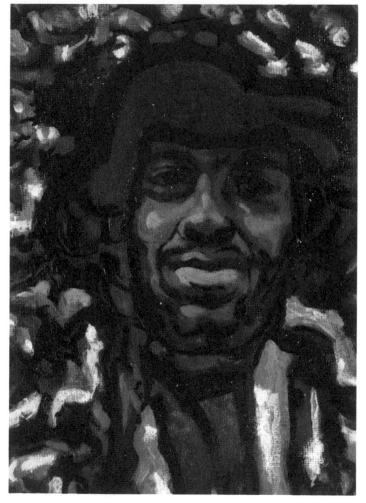

"leathery reliqary in my thin falsetto"

Adrian Matejka

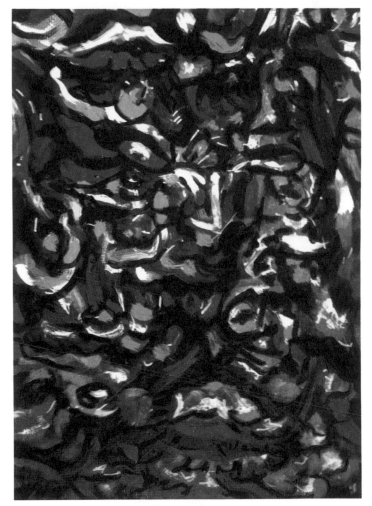

"up the backside of a treble clef"

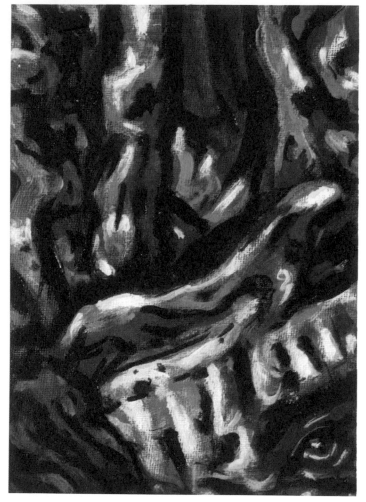

"actual epistle"

Adrian Matejka

Jimmy's Got

...reality can be hard...

a fistful of frustrations after all of the indelicate
male deconstruction. It's easier to turn around
& leave the angled convocation of beautiful men
& their bearded insecurities than to stay here arguing

with gravity. Somewhere, snare & cymbal successively
snarl just like *yes no yes yes* as if percussion translates
brain arguments & consent. Somewhere, sunlight
submits in the room with the balcony & reasonable

view until fuck, yes. The one I was looking for
between apparitions & high hats reclines on a blue
couch with a dog sleeping in his lap. His Diasporic
smile upsets whatever bright balance there could

have been. It's been a long time since the first man.
That afro. Gracious. That chin like an actual fist.

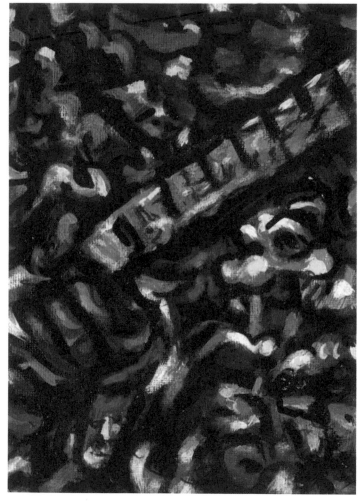

"the angled convocation of beautiful men"

Adrian Matejka

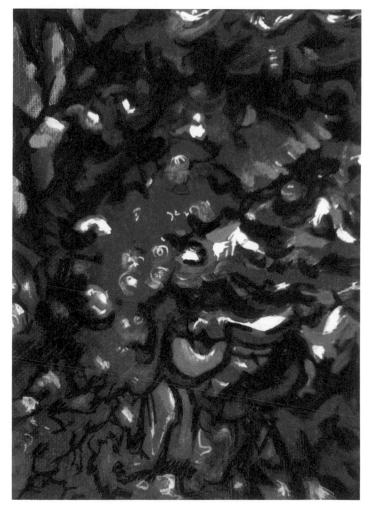

"crescent moon tattoos & heart-thumping festoons"

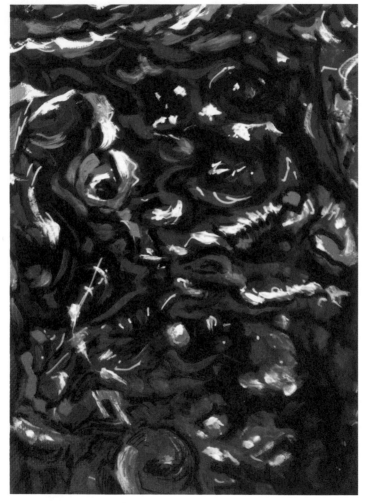

Adrian Matejka

"brain arguments & consent"

Good Thoughts, Bad Thoughts

...good thoughts bring forth good fruit...

So many blushing invitations in the hibiscus
evening, tingling promise rings slipped
on earlier in the habit of fixation & *whatever
it takes* to get it in. I think *it* includes thumbs
& surprisingly long tongues. It includes safe
words for honest conversations. So many
underserved possibilities — ribcaged inquiries,
half-mooned with crescent moon tattoos
& heart-thumping festoons. I can't wait to lick
all of it off of you with something other than
metaphor. Listen, please, because I love you
like a solo loves a guitar: extravagant exhales
of us, minor lights because gravity pulls up
& toward the difficult center of my concaved
chest. You hear that? Profit & blood. Yes.
Meanwhile, one eye stays closed to the fun
as we procession straight to the yelling sun.

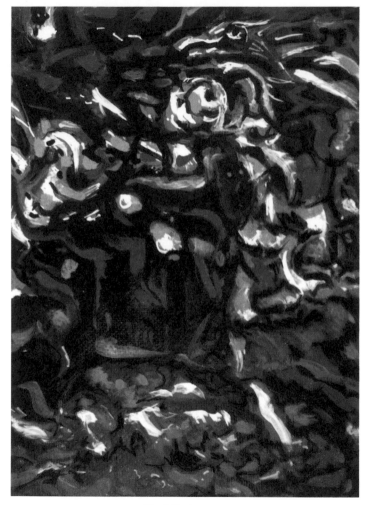

"the difficult center"

Adrian Matejka

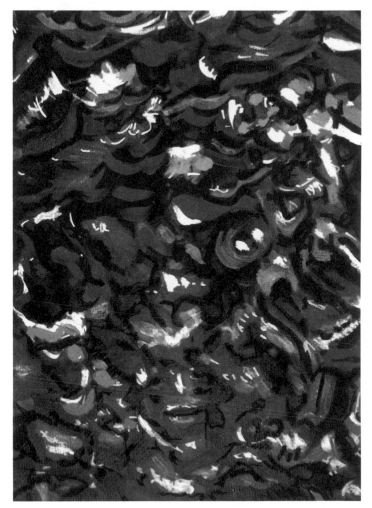

"for my late-night addendums"

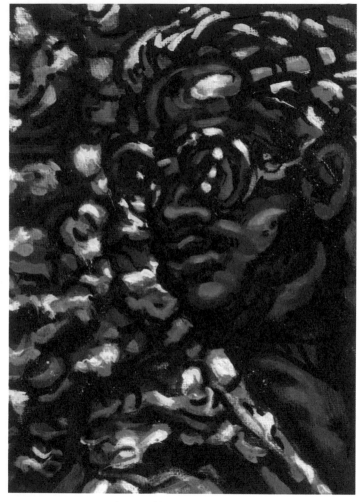

Adrian Matejka

"I love you like a solo loves a guitar"

*Vital Juices (1975 Version)

—for Eddie Hazel

Some things stay
red hot
 & symmetrically
 split. Yeah.
Vital & slick.

 A whole silhouette
of smoke flipping around
 itself like a tongue

stuck in the fishnet
of sweet intent.
 What an aberrant

 flock of us. What
 an absolution pretending
to be patient minutes before

alchemy makes a guitar
 where the tongue
should be. Indents on

both sides of the spine's
directive, half
 circled into a hand-

drawn sky
between skirt grip & hem.
Incantations
 of hair, dimpled

 spectaculars on the low
 back—what an exquisite

Saturday, backlit
 by the spotlight
 where the get-loose

strata better be.
In this glint-thick
 insidious slip,
stomachs & the conga's

 ass-slapped octave
 in the blacklight strobe.

*Standing On The Verge Of Getting It On (Single Edit)

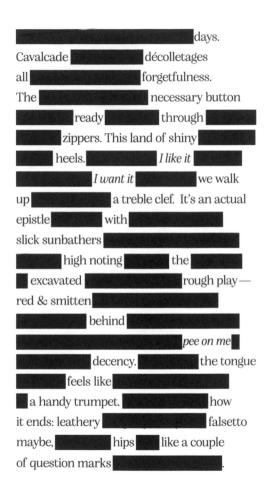

days.
Cavalcade décolletages
all forgetfulness.
The necessary button
ready through
zippers. This land of shiny
heels. *I like it*
I want it we walk
up a treble clef. It's an actual
epistle with
slick sunbathers
high noting the
excavated rough play —
red & smitten
behind
pee on me
decency. the tongue
feels like
a handy trumpet. how
it ends: leathery falsetto
maybe, hips like a couple
of question marks .

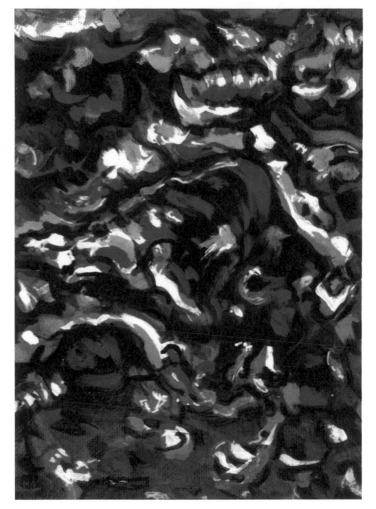

"red & smitten"

Adrian Matejka is the author of five books of poetry including the forthcoming collection *Somebody Else Sold the World* (Penguin, 2021) and *The Big Smoke* (Penguin, 2013) which was a winner of the Anisfield Wolf Book Award and a finalist for the National Book Award and Pulitzer Prize in poetry. He was Poet Laureate of the state of Indiana from 2018-19.

Kevin Neireiter uses a wide variety of mediums in his art. These include paint, pastel, clay, wood, or any other objects found around his home. Many of his paintings are an attempt to describe what he hears in music. Kevin was thankful to have been asked to create the cover for Adrian's debut book, *The Devil's Garden*. When he's not making art, he is usually making music or maintaining a Funk shrine. (The Funk shrine is a sculptural homage to Pedro Bell's album cover for Funkadelic's *Standing On The Verge Of Getting It On*.) He currently lives in Seattle, WA, with his two daughters and his dog Ringo.

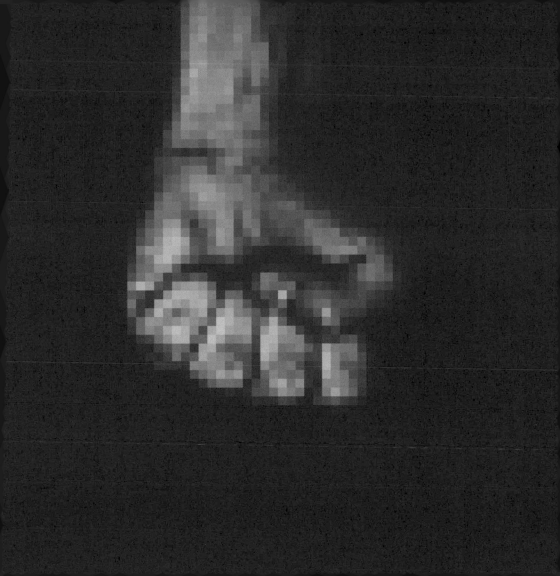

Nicholas Galanin roots his work in his perspective as an Indigenous man connected to the land and culture he belongs to. Over the past two decades his work has ranged across media, materials and processes; in which Galanin has splintered tourist industry replica carvings into pieces, the rearranged pieces evidence of the damage of commodification to culture through photos, objects, and video. In 2020 Galanin excavated the shape of the shadow of the Capt. James Cooke statue in Hyde Park for the Biennale of Sydney, examining the effects of colonization on land, critiquing anthropological bias, and ultimately suggesting the burial of the statue and others like it. In 2021 he created a replica of the Hollywood sign for the Desert X Biennial in Palm Springs, CA, which reads INDIAN LAND, directly advocating for and supporting the Land Back and Real Rent initiatives. Galanin holds a BFA from London Guildhall University in Jewellery Design and an MFA in Indigenous Visual Arts from Massey University in New Zealand, prior to which he apprenticed with master carvers and jewelers in his community; he is represented by Peter Blum Gallery in New York, his music (as Ya Tseen) is released by Sub Pop Records in Seattle. Galanin lives and works with his family on Tlingit Aani, Sitka, Alaska.

"there's not a word for stop when your jawbone gets used as a washboard."

That was a long time ago,
 before the bruises in the back

 bus seat, split-vein lightness
& eye-watering staccato

as the buggy winds it slow
 way past snow drifts & husks

 of cars at the edge of the local
pleas: *Go maggot brain. Go.*

In the route, some things
 stay regretful & significant:

 sputtering lights up top,
memory of summer someplace

else pleasing in pool light.
 Stretched out longways,

 a daiquiri melting helplessly,
you staring at the thumping

sun while old catch phrases
 wash up at the lip & a moth

 bobs toward the filter. *Go
maggot brain.* In the drafty

aftermath, there's not a word
 for *stop* when your jawbone

 gets used as a washboard.
Scrape of knuckles, whelped

skin from washing bumps,
 from washing mosquitoes

 or needles on the way down.
Flip of cigarette at the thick-

tongued city. Maggot brain,
 somebody downtown is sick

 & losing a mama now: *Go
maggot brain. Go, maggot brain.*

The ubiquity of a jail cell tastes clammy,
like everything was a mistake immediately.

Bologna is the coin of the realm. Toilet
paper causes minor riots: shredded shirts,

slow comedowns & sterno cans brightening
the glare of wedding rings exchanged

in the backyard of forgetting. It doesn't even
matter in this incarceration of gold fronts,

dull reflections in metal sinks in the corner.
Somebody in the cell over is yells through

the start of withdrawal about being late
for his appointment. Everybody's time:

snatched, & its ticking innards ricochet
on cold drives from the suburb to urban renewal,

from the insistence of late rent, fenders rusting
in lake snow while the people still harmonize.

We are made out of bare needing, even in winter.
Somebody in the cell over yells over & over.

We are made out of blustery forgetting, out
of hindsight to back before your face & ribs

got beat until they bruised like a low-tide lake.

"The ubiquity of a jail cell tastes clammy"

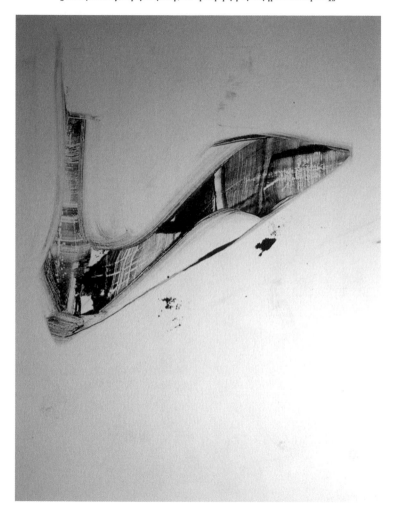

"I woke up walking in high heels on the river's leather animus."

Click: that's what
 happens down here
 in the whole note
dream when George
Clinton says *Play*
 like your mama

just died. Blink,
 slink. It's drippy
 on the aortic bridge
& way past time
 to sing anything else.
 She's already gone

& shadows swerve
 penthouse tall in
 the busy-body
tradition. Ain't
 you supposed to be
 the ADG collation?

Perfume on the hand
 towels linger for
 at least a week
after she leaves. Not
 your mama, but *her:*
 remember, please

in the sad, yowling
 dissatisfaction.
 Please, remember
the mis-remembered
 romances: heart
 beat, sharp breaths

in the clatter. Another
 habitual, choral
 epiphany. That's
when I woke up with
 a litany in the middle
 of a cottoned mouth.

I woke up
 walking in high
 heels on the river's
leather animus.
 Maggot brain,
 maggot mane,

later for woebegone
 ubiquity & narrow
 throats as we sing
an aubade of made
 out of idioms
 in an early-ass

boat on the Detroit
 River. It's morning.
 All the rest becomes
stomach aches by
 the handfuls, clammy
 as a comedowns.

"She's already gone & shadows swerve penthouse tall in the busy-body tradition."

Meanwhile, the insistent singers
 shift interludes as willingly
as others wink & fuck in bathroom

stalls: zip, lift, bent over raggedy
 reservoirs, sloshing in the same
plumage as the funk's octave—

at the end of hallways where angry
 overhead lights blink every step past
claptrap doors, padlocks dangling

the way busted hearts do. Maggot
 brain, maggot my main man: there's
a story under every story, vivid

inside fraudulent stars & augmented
 bustiers. Lonely, since nobody
can distance themselves from gravity,

the long pull of glitter in the glory hole.
 See them lift & perk in the ether.
See the heart & brain cluster in extra

anatomies: another cosmos of hums,
 tapestries of never lifting a pinkie
ring off the E string. Mouth of missing

scenes. Teeth, stickling a long dream—
 click of brain, snap of mousetrap
on the four-fingered way down.

"padlocks dangling

the way busted hearts do."

"I once had a red hammer in hand & played it in the freight car of my singing emancipation."

Let's talk about the metronome of loss: I once had hungry chatter
before it got unsustainable. I once beat everything around me
down like an unrelatable heart. Once I started at the skull-browned
edge before it got unreliable & bland. I once had a red hammer
in hand & played it in the freight car of my singing emancipation.
I once had, I once had. Two guitars from the pawnshop instead
of feet & I still couldn't swing. A woman so fine I quit eating
meat of any kind. I once had sixteenth notes where some people
have gears. An altruistic jones for touch despite my half veneers.
So much I didn't matter as much. I once had a heart but sold it
for sauce. I once had some semi-glossed gators but lost them
in the static. Really: I had a double cross & a six-string,
Cadillac status. I lost both beauties in alley traffic. Really: I had
somebody who loved my interludes & strings together. Imagine:
anybody willing to love this busted up, wah-pedaled endeavor.

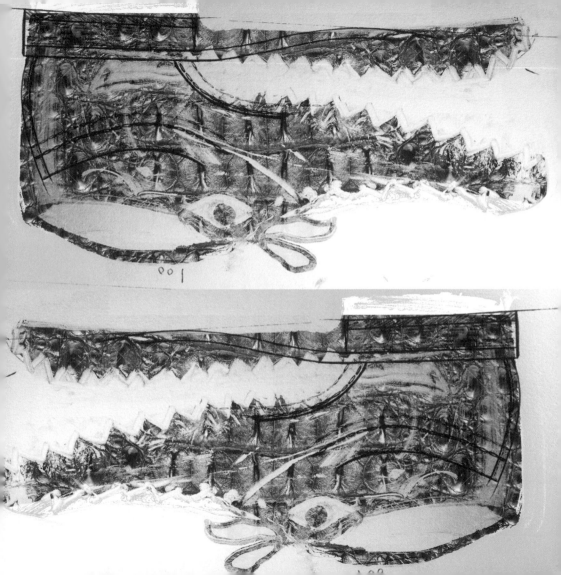

"Some alligators have whole mouths full of teeth sharp as Saturday & still end up as shoes."

Ain't you supposed
to be discreet inside
this sorry song like
notes made of teeth?
Ain't you supposed
to skip the wet alley
of heartbeats? As many
questions as beliefs
before the needle
& need. In the brainpan,
light fixtures are vacant
like they always are
in abandoned houses.
Flick of empty switch:
notes conscripted
& amalgamating &
somebody out there
is hoping for a place
to glitch. They throw
a protest brick made
from sound into
your amp stack anatomy.

They giggle as speaker
& preamp tumble
intimately. Maggot
brain, foil packs crumple
the same way: bend
of fingers, bend of brain
arcing in spent lighter
light. The knuckles rising
behind that twitchy
brick are a silhouette
of mountainousness—
left loves, lost guitar
picks, dropped afro
picks on the dash to cop
& then from a cop,
his nightstick slapping
hip with each broganed
leap. Big chested,
precipitous escapes
down gorge sides
as loose rocks follow
your scramble, through

rivers & glens where
animals barely pause
while you sprint by
in a leather jumpsuit,
feather still in your brim.
The natural haze
of escape instead
of being here on the nod,
hanging onto the guitar
neck while the floor
drops out from underneath
your alligator boot
knobs. Some alligators
have whole mouths full
of teeth sharp as Saturday
& still end up as shoes.
Sometimes necklaces,
too, swinging hungry
the way metronomes do.

Somebody, please put something
over that window with the star
crack in the middle: some cardboard

bent into the intimate, maybe, some
plastic stretched like an unnecessary truth.
Guitar feedbacking its imaginary arc.

Please, somebody, cover it with
whatever's close because I can hear
the instinct machine scratching

the clothes line outside with asthmatic
fingers. I can hear quadrophonics
swinging in double digits: huffed up

harmonics fidgeting on the one
like a wheeze still trying to breathe.
Please, somebody put something

over that empty socket of winter.
The bus never shows up on time.
Blame it on lake snow. Blame it

on maladroitness: I can hear bleak
squeaking coming around the block
like a soloist on his last encore
for the evening. So many ambidextrous

players, excess & rust in the mind:
maggot brain, maggot brain.

Too much road salt & seasoning
in Detroit this evening. Ain't you
supposed to triplicate into more

than this mess like a breezy heart?
Ain't you ready for this solo part?
The chamber below your frets is just

the start of breathing. Put your guitar
in its lung before the headlights
spotlight your leaving. Put your hat

on, too, so you don't hear December's
cold leanings: southward where
notes ought to be—winged in bright

flight. It's nearly here: struggle buggy,
sorry wagon of rickets & laments
for the cricked necks & bird leery.

Adrian Matejka

"Ain't you supposed to be discreet inside this sorry song like notes made of teeth?"

Maggot Brain
– for Eddie Hazel (1950–1992)

Contents

FOR MORE INFORMATION
Password: Funkadelic

For more information:
Third Man Books, LLC, 623 7th Ave S, Nashville, Tennessee 37203.

ISBN 9781734842296

Layout by Maddy Underwood

THIRD MAN BOOKS

MAGGOT BRAIN

Words
Adrian Matejka

Art
Nicholas Galanin

Music
Funkadelic

I have always worshiped the poet, the poet is a shapeshifting
mastermind bringing emotions, histories, and ideas to the realm
of the living. In *The Big Smoke* Adrian Matejka reminds me that
Jack Johnson is America, made in America and a product of its own distorted
myths. In *Maggot Brain*, with word and the memory of
a song that is both a sacred lullaby and a fight song, he has opened
a portal to reclaim a complicated love.

– Meshell Ndegeocello